the
Merchant
of
Marvels

and the
Peddler
of
Dreams

Will you ... Can you be tempted?

THE MERCHANT OF MARVELS AND THE PEDDLER OF DREAMS

Frédéric Clément

CHRONICLE BOOKS
SAN FRANCISCO

First published in the United States in 1997 by Chronicle Books.

First published in France in 1995 under the title
Magasin Zinzin ou Aux Merveilles d'Alys by ipomée-albin michel.

Printed in Belgium.

ISBN: 0-8118-1664-8

Library of Congress Cataloging-in-Publication Data available.

Cover Design and Calligraphy: Doug Andelin
Text design: Jill Jacobson
Photographs: Vincent Tessier
Book Design: Frédéric Clément in collaboration with Sabine Turpin
Translation: Emma Cole

Distributed in Canada by
Raincoast Books
8680 Cambie Street
Vancouver, B.C. V6P 6M9

10 9 8 7 6 5 4 3 2 1

Chronicle Books
85 Second Street
San Francisco, California 94105

Web Site: www.chronbooks.com

To Alys,
the merchant of marvels

I t is well known,

from port to port, from valley to valley,

from village to village

that you are the merchant of marvels.

I've heard it said, on the train tracks and highways,
the dirt tracks and byways,
 that it will soon be your birthday.

 There is even a rumor
 that the choice of your present
 will be difficult
 as your shop has so many secret surprises

So there we are.

Allow me to introduce myself
Frederick Knick-Knack,
merchant of matches,
of watches,
of bluetits,

OF MIRRORS,

of sand, blackbirds, and
berries,

traveling tradesman in time and in hours,

a peddler of dreams
for celebrations and birthdays

on the train tracks and highways,
on the dirt tracks and byways.

And
surely I have

in my bags or my boxes,

in my chests or my cases,

IN MY LITTLE CART

or hidden away in the back of my shop,

Surely I have

a marvelous marvel,

a sheer folly
to tempt you.

Grant me, if you will,
a few moments of your attention.

I would like to show you
my collection of collections.

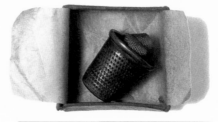

A thimble to stitch with

Firstly,

allow me to show you
two precious thimbles:

a thimble to stitch with and a thimble to unstitch with.
In the first thimble, I store summer dresses:

a wheat gown
a corn gown
a barley gown
a hot air balloon ballgown for windy Sunday
a blueberry-bush gown
to nibble at on nippy mornings

a red robe,
crumpled like a young poppy
a pleated robe coated in chocolate
a robe spun from shooting stars
with a Milky Way veil

A TINY DRESS OF NOTHING AT ALL
tailored, I am sure, from a sheet of rain

an
aviary
frock
from the
Bird's Market
with a secret little door on one side

for parakeets and parrots
for hummingbirds *and* finches

a dress with a long train
like a path in Provence
trailing cicadas, crickets,
and *s c a m p e r i n g* rabbits

a motoring dress
furnished with wheels,
a horn, pink velvet seats
and in the glove box,
two white satin gloves.

And then,

11

A thimble to unstitch with

And then,

folded away in the second thimble
is a ravishing winter dress

which *turns*,

TURNS,

turns like a merry-go-round,

and when you t u r n ,

t u r n ,

t u r n the handle on the left hand side,
just next to your heart,

IT SNOWS

on the waltzing wooden horses.

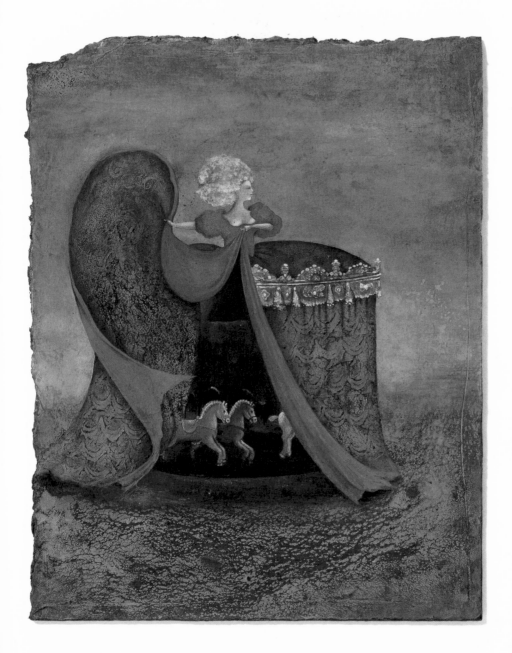

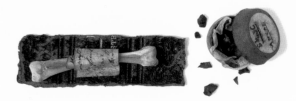

Freckled frog's thighbone and pieces of magic wand

But now, for something completely different

I just happen to have on hand
A FRECKLED FROG'S TINY THIGHBONE
from the wicked fairy Carabossa
and some fragments of her magic wand.

The red-haired woman in Casablanca
from whom I acquired them
assured me that one single fragment of a fragment
of Fairy Carabossa's magic wand

finely ground with
the freckled frog's
tiny thighbone was
enough to reduce an
elephant to the size
of a speck of sand . . .

And funnily enough

Elephants the size of grains of sand

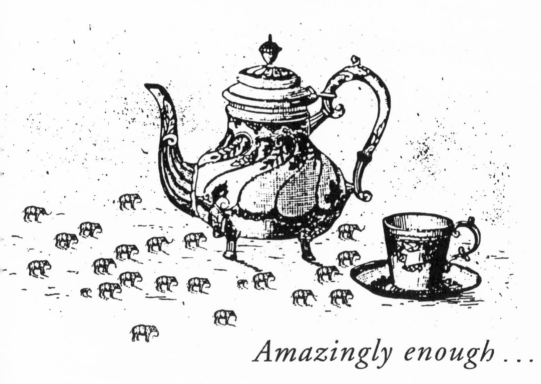

Amazingly enough . . .

I also have a troop of elephants
all as small as specks of sand
who come trumpeting from time to time
into my teacup.

Let me entice you, my dear,
LET ME TEMPT YOU . . .

Tip of Pinocchio's nose

Or, if you prefer something unique,
I can offer you certain *priceless relics:*

the broken end of Pinocchio's nose

two of Puss-in-Boots' whiskers

Left whisker Right whisker

*one
of
Tom Thumb's
pebbles*

or

Thumbelina's cradle:

A NUTSHELL
with rose petal sheets
and mattress of violets,
still warm from her slumber.

And most especially,

an eyelash
stolen from the Queen of Sheba.

A flying hat's egg

And then, in my collection of marvels,
I have, carefully, cautiously placed upon cotton,

a red,

round,

and rare egg

which was given to me
by the great-great-great granddaughter of the Pampelune hatter,
a tamer of flighty hats for his Majesty,
the King of Navarre.

I must tell you, my dear friend, that in those days,
the flighty hats flew freely as air
from ocean to ocean, port to port, from girl to girl.

And, my dear, at that time, in the courting season,
the flighty hats rested and nested
on the highest hairstyles of the Pampelune maidens.

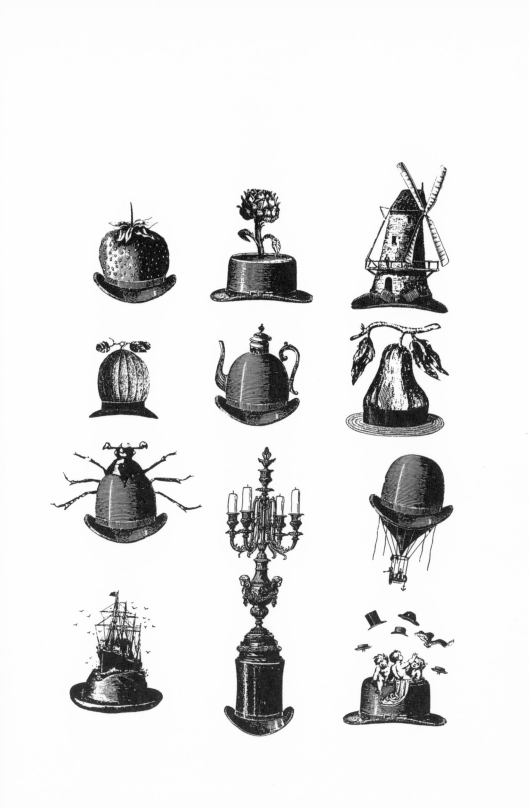

Now,

imagine, my dear . . .

Imagine the beautiful ladies of Pampelune,
who danced every night by the light of the moon,
in the center of the great town square.
They had coiled and crimped and curled their hair.

Eyes to the sky, they watched and they waited,
hearts beating hard, hoping,
that a hat would land
and lay
on top of their hair,

its exquisite egg
red,
round,
and rare.

YOU

have the unique opportunity to possess one of them
carefully, cautiously, prudently placed upon cotton.

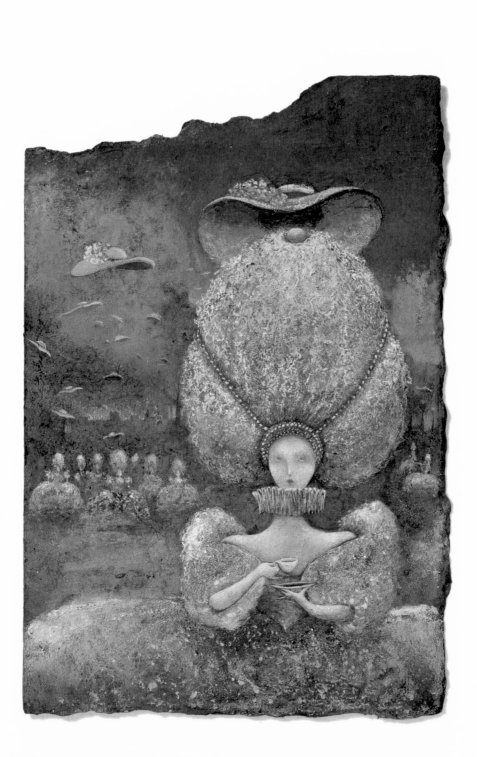

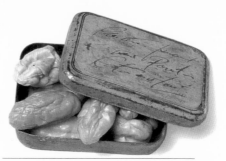

Souvenirs of a curious camel

Or perhaps . . .

From my tiny tin box,

THESE NINE SOUVENIRS
chewed and chomped
by a curious camel
as old as the desert.

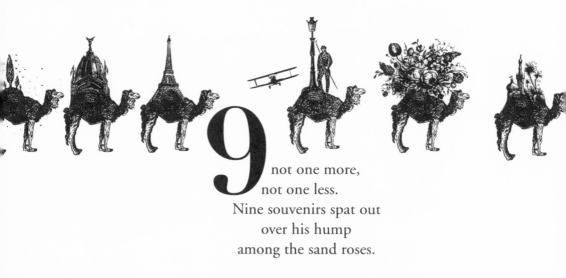

9 not one more,
not one less.
Nine souvenirs spat out
over his hump
among the sand roses.

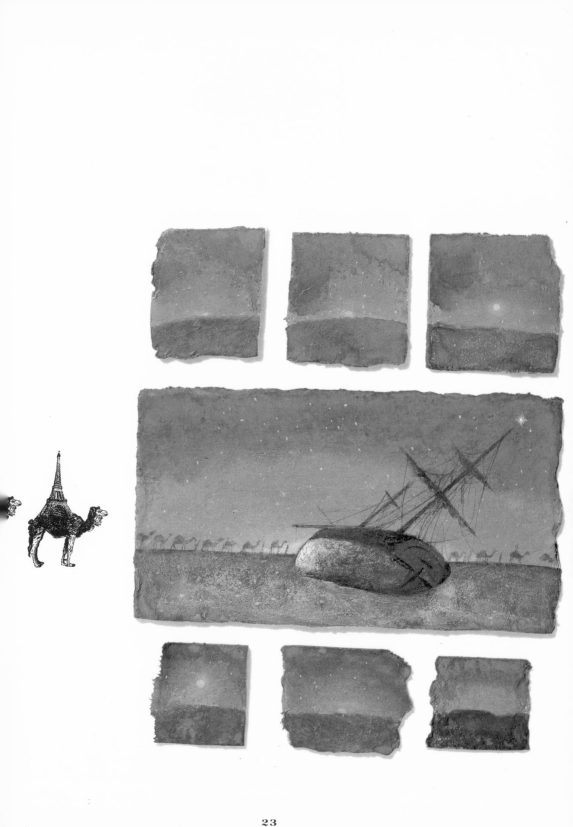

Shadow of a little prince

On the subjects of roses and of sand
I have, in a chestnut chest,
a fresh shadow,
well ironed at the neck and the cuffs.

A shadow found in the setting sun
at the foot of a street lamp
in the middle of the Sahara desert.
The long shadow of a child,
who has, in his left pocket,
a pinch of sand,
a rose petal,

and

A THORN,
sharp and deadly.

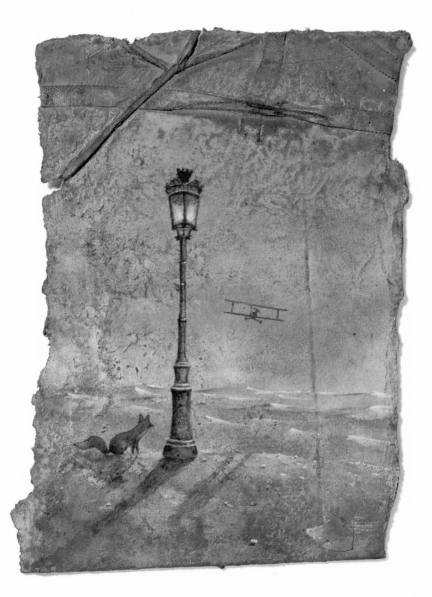

Winning ticket for the flying carpet tours

I fear I miss the mark . . . *let me see* . . .
Oh yes!

Is the wanderlust upon you?

It was I who won the raffle at the Fairyland Fair,
A TICKET
for a thousand and one flights
on a thousand and one nights
aboard a flying carpet
a velvet carpet
piloted, if you will,

by Captain Nemo himself!

So, might I invite you
to a thousand and one flights
ON A THOUSAND AND ONE NIGHTS?

Ogre baby tooth

Or,

if you prefer shivers and shudders,
I have the following:
in a folded handkerchief,
one of the baby teeth
of the Ogre of Hurdy-Gurdy land.

You must know that, even as a mere child,
for his afternoon snack,
the Hurdy-Gurdy Ogre
DELICATELY MUNCHED
a dozen little girls' thumbs,
flavored with cherries and essence of plums.
and, *with his little finger in the air . . .*

for even as a
very young ogre his
manners were polished

he crunched and munched politely,
as quietly as he possibly could.

It is rumored that for his birthday
the spoilt giant asked every year
for a cake filled with little boys,
coated with chestnut custard
and topped with clouds of whipped cream.

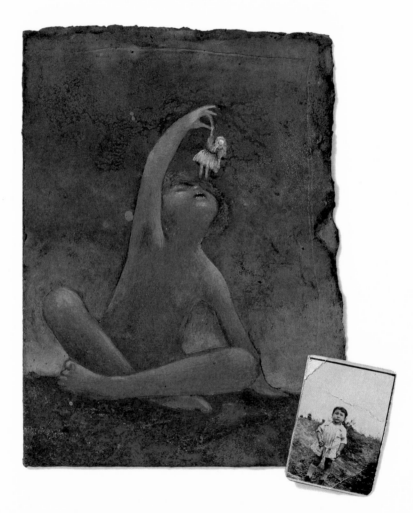

So what do you think, my dear?
AN OGRE'S BABY TOOTH—
is it not a charming and original present?

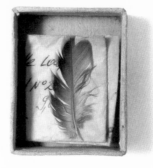

Mr. Doisneau's sparrow's feather

Pray, permit me to propose
the actual pea,
perhaps a little squashed
but carefully preserved,
of the Princess and the Pea.

Or,
also,
from my famous feather collection,
a feather from the well-watched little sparrow
which escaped from Mr. Robert Doisneau's camera.

r

the Mona Lisa's beauty spot.

Or,

two of Punchinello's sweet secrets:
the secret of the guzzle and gulp method

or

the secret
of the melting in the mouth method.

Let me see . . .

A lock of mermaid's hair

Why not this little jewel
which I sometimes furl around my finger:

a lock of hair from a mermaid,
Queen of the seas and the sea anemones,
long,
long and red,
like the sunset on the horizon.

It was her harbormaster husband

long since changed into a cormorant

who traded it with me in a bar in Corfu
for two thimblefuls of delicious sweet wine,
three scarlet shrimps from the Outer West Indies,

A lock of mermaid's hair

two orange oysters from Haiti,

a blue fish from the Red Sea,

Captain Nemo's cap,
the stationmaster's whistle from the town of Timbuctoo,
a gazelle's horn,
four cats' tongues
a white rabbit's watch.

And especially
for the promise
never to tell anyone.

And especially

especially

not his mermaid wife,
Queen of the seas and the sea anemones.

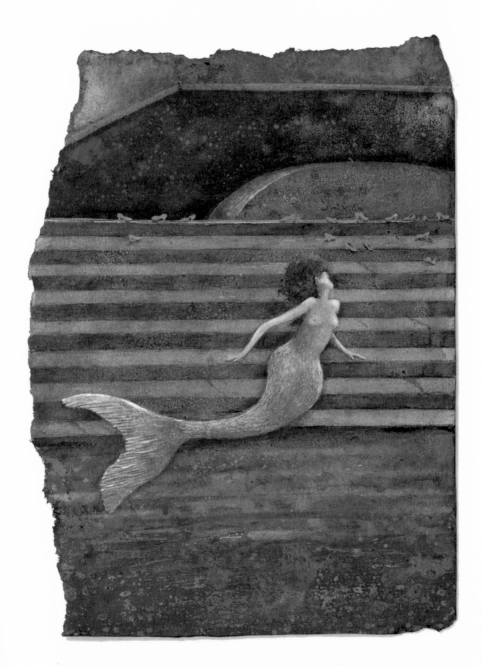

Snow White's lip rouge and powder pot

Something even better . . .

Many years ago,
at the Warsaw flea market,
I bought
for a song, a mouthful of bread and three apple seeds,
Snow White's
powder pot, LIPSTICK,
and garter

from a Russian rabbit, an ancient lace peddler,
at least a hundred years old, with a toothless grin.

Will you ... Can you be tempted?

Perhaps this casket containing
the very same splinter
which pricked Sleeping Beauty?

But
be careful
not to prick your finger . . .

A sliver of the splinter

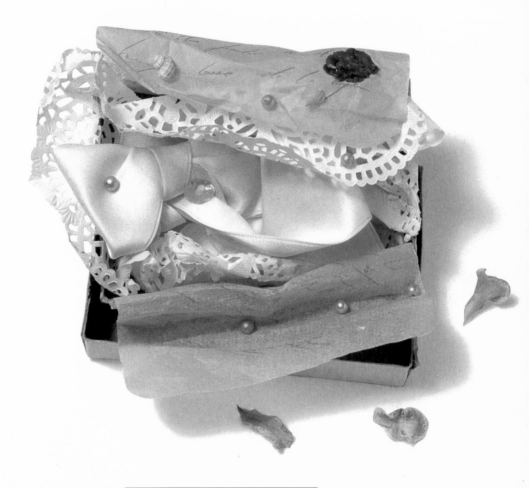

Snow White's garter

Merlin the Enchanter's marble

You must also take care

if you choose the *marble* made by

Merlin the Enchanter.

For imprisoned within its heart of glass is

the *w i c k e d e s t* wave

of the wildest storm

that the Earth has ever known,

with foaming teeth, mast-munching molars,

with

gull-gobbling hurricanes,

with

sailor-swallowing, whale-wolfing tornados.

But BEWARE, I beg you,

beware

of shattering the marble,
for
there would be
a dreadful deluge,
a disastrous shipwreck
with
thunder,
lightning,
and showers of glass.

Fragments of the palace of the King of Snails

Safely stored in a silk scarf,
I HAVE A MARVELOUS TREASURE:

Some fragile fragments of the palace
of the King of Snails,

a present from an Indian swami
who told me tales
of celebrations, of concerts,
and moonlit balls.

the stars of Bengal
and the fireworks
were so beautiful,

so blue that the River Ganges still bears, still glimmers
with their reflections . . .

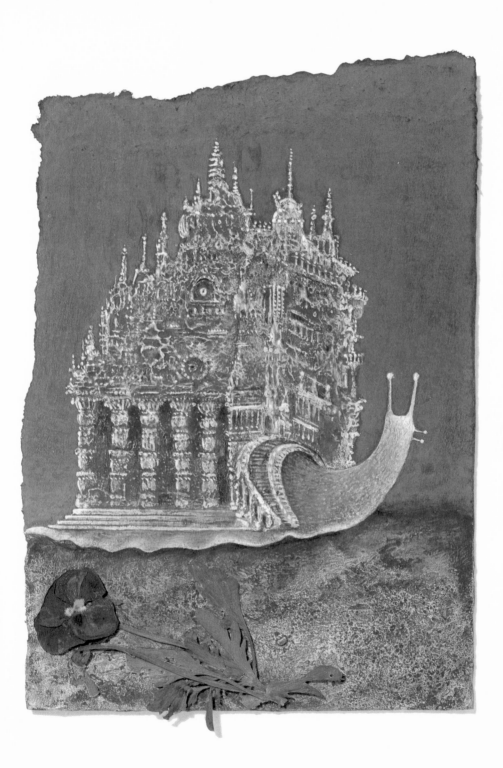

Tear Liqueur of the King of Crocodiles

And as we are in the royalty department,
allow me to suggest
this set of three vials
filled with a precious potion:

the

TEAR LIQUEUR

of the

KING OF THE CROCODILES

carefully collected on the banks of the Nile
amongst the bric-a-brac of a morose medicine man.

On the label it is written thus:

A tear
on the tip of the tongue
TRANSFORMS
bad words
into *yellowhammers,*
into *bluetits,*
into *redbreasts,*
into *blackbirds,*
AND
gold nuggets.

On the label is also written:
A single drop on the end of the nose
TRANSFORMS
great sorrows
into

great gray cats
with green velvet eyes
and a pale smile
like a crescent moon...

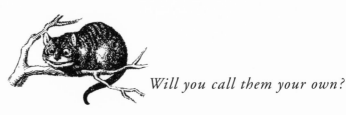

What do you think, my dear,
may I put them aside for you? *Will you call them your own?*

41

Pumpkin seeds

I possess pumpkin seeds
and
carriage seeds

If you are planning to go to the Spring Ball,
you had better plant now

the carriage seeds

Except, of course,
if among your associates you have an aunt,
a friend or A FAIRY GODMOTHER . . .

In *that* case,
the pumpkin seeds will suffice.

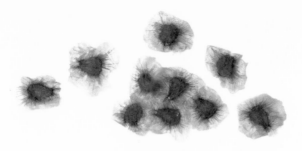

Carriage seeds

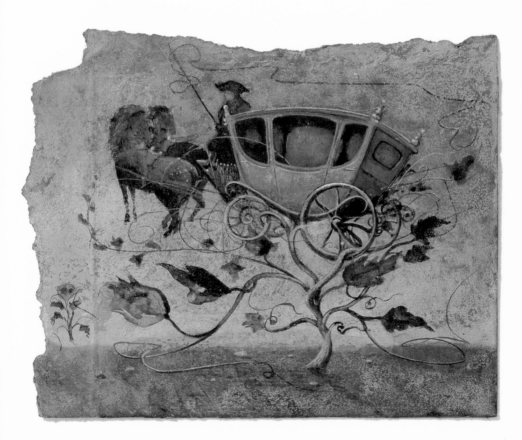

Oh, yes! Even better . . .

Cherub bell

From Vienna, I have the little round bell
of one of the cherubs who hover
above the roofs of the town
at Angelus hour.

One morning on my balcony,
I found a little cherub,
wounded, chilled to the bone.
A ravishing cherub,
all rosy,
and round,
with two blue wings
on his back,
all crumpled and creased
from the fall.

And for days upon days,
nights upon nights,
I tended him, healed him
watched over him and fed him
on nothing
but redcurrant jelly.

And then once he was healed
I opened the window onto my balcony,
at Angelus hour.

The cherub rejoined his herd,
up on high,
as is every cherub's destiny

44

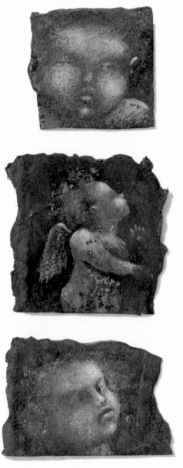

And, as luck would have it
he had forgotten his little bell on the chimneypiece,
a bell all cherubs wear on their left ankle.
I kept it as a souvenir.
So, please take this . . .

which I offer, openhearted.

Saltshaker for hunting wild pianos

If you like music,
my dear,
here is the saltshaker,
the indispensable and most necessary saltshaker
for hunting wild pianos
who live alone
on the slopes of Mount Kilimanjaro.

Every good piano hunter knows
that the best time
to catch a young piano

is at dawn.

When the piano, still sluggish with sleep,
laps up with delight the sugared dewdrops
at the foot of the baobabs.
Make the most of his greediness,
tiptoe towards him, softly as you can
the saltshaker
between the finger and thumb
pour a pinch of sa
ON the piano's tail.

Bravo!

Thus will the most ferocious of pianos
become as gentle as a lamb.

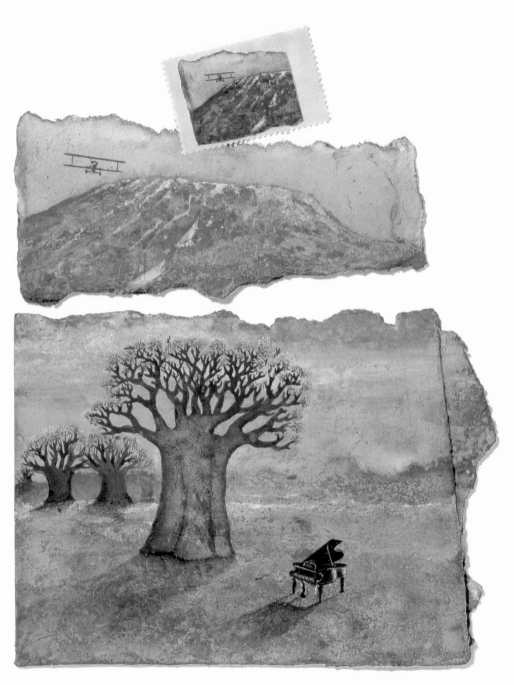

Once tamed, he will permit you
to tinkle out tunes for hours
and hours and hours and hours
and hours and hours and hours . . .
I guarantee you will be enthralled . . . But

Giraffe flowers

Now
I would like to bestow upon you
another of my African treasures:

the priceless giraffe flowers

You see,

on the last stormy evening
in the rainy season
giraffes display themselves,
giraffes *u n f u r l* their long necks
towards the few remaining clouds
and NIBBLE at them
like cotton-candy.
It is precisely at this moment,
in the twinkling of an eye,
that a giraffe *b l o s s o m s .*

Imagine, if you will, the enchanting spectacle
of the careening flight of the blossoming giraffes.

Close your eyes,
and imagine
a little . . .

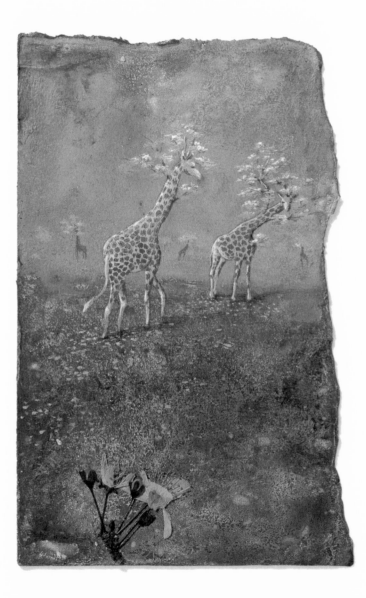

Cinderella's peals of laughter and
shards of her glass slipper

 Close your eyes . . .
Listen,
in a cardboard case

I have *seven* peals
of Cinderella's *l a u g h t e r,*

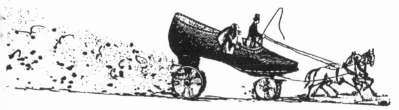

stored with *six* fine shards
of her *splendid g l a s s s l i p p e r.*

Take them, then,
your eyes closed,
take them . . .

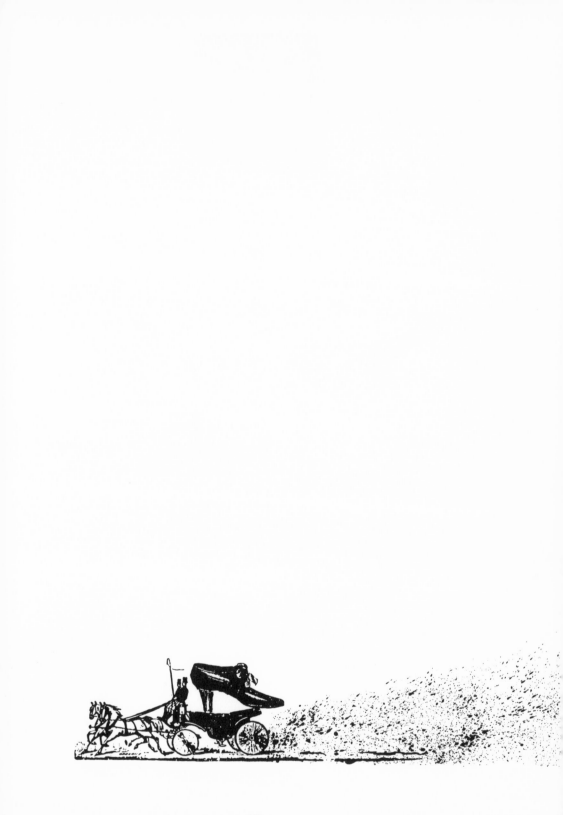

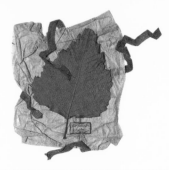

In a scrap of crumpled paper

I have a poplar leaf which was,
in former times,
the intimate friend,
the CONFIDANTE,
of the most sought-after singers,
the most well-known whistlers

at the Rare Bird Opera.

It knows all the yellow songs
that the white blackbird sings in the rain,
the ravings of the raven
and the emotional flutterings of the enamored finches.

It knows by heart the rues of the robin.

There is nothing it does not know
of the sobs and the sighs
of the blind nightingale
which dwells
in the gardens of the Sultan of Balima,

not to mention the gallant gabblings of the goose
and the prattling of the parrot . . .

To

hear the stories, all you have to do
is open the window
and let in the breeze.

Thus will the poplar leaf
begin to tell the tales,
half-heartedly at first, but then in full voice
of the golden life
at the time of the Rare Bird Opera.

Would
you like
to try?

And then . . .

and then, my dear,

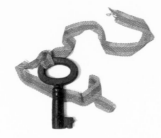

Key to a box of keys

I have a clock,

from the clock hangs a key,
the key to a most beautiful box
full of keys:

the key to the open fields
bordered by a little blue boating lake and some red dancing poppies,
the key to *sandcastles,*

the rusty red key to BLUEBEARD'S BLACK BOX

the key to a *lighthouse*
as large as the North Star

the key to a yellow submarine,

the key to the *secret love pavilion*
of the Marquise of Pompadour

and then

and then
the key to a very deep well.

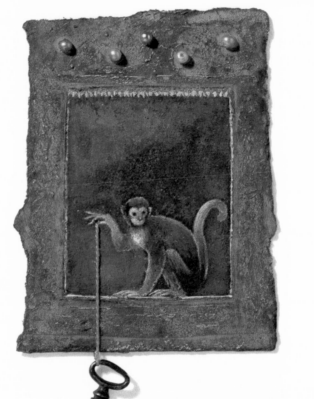

And at the bottom of this deep deep well:

lies a key I obtained from a magic monkey,
a *dealer in dreams*
on Paradise Street in Paris.

Go there, *my dearest,* tell him I sent you,
and he will give you the key,
the magic key,

the little golden key which opens up the secret world of all dreams

the world of dreams
where eyes open wide
mouths open wide
ears open wide

and

especially my arms open wide

wide, wide open
open wide *for you,*

my dearest friend
<small>my love</small>

my marvelous
merchant of marvels.

Since 1949, Frédéric Clément has pursued the same career: dream weaver. He shares this dangerous profession with a passion: collecting. He collects time (in particular precious minutes, blue with gold-spotted wings), young waves with baby teeth, shipwrecked islands and lighthouses, worn-out books . . . and since 1994, et cetera takes up a lot of his time. By trade he is a designer, writer, creator of books, and general maker of marvels; by ambition his work has appeared in numerous publications. His true love is the illustrated book, and his work has received enough awards to fill a treasure chest, several hatboxes, and a painted wagon or two. When not traversing the Milky Way or dabbling among the clouds, he lives in the Paris area, spinning beautifully illustrated tales.